D1387981

If you're happy and you know it...

Andre Jordan

JOHN MURRAY

First published in Great Britain in 2007 by John Murray (Publishers)
An Hachette Livre UK company

1

A CIP catalogue record for this title is available from the British Library

Hardback ISBN 978-0-7195-2186-7
Trade paperback ISBN 978 0 7195 4660 5

Typeset in Child's Play

Printed and bound in Great Britain by William Clowes Ltd, Beccles, Suffolk

John Murray policy is to use papers that are natural, renewable and recyclable products and made from wood grown in sustainable forests. The logging and manufacturing processes are expected to conform to the environmental regulations of the country of origin.

John Murray (Publishers)
338 Euston Road
London NW1 3BH

www.johnmurray.co.uk

This book is dedicated to my psychotherapist, Denise

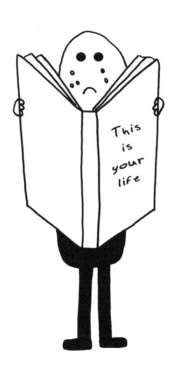

My father once said
I was a
waste of space

I am determined
to prove him
right

The matchstick's luck
had finally run out

I am a chicken

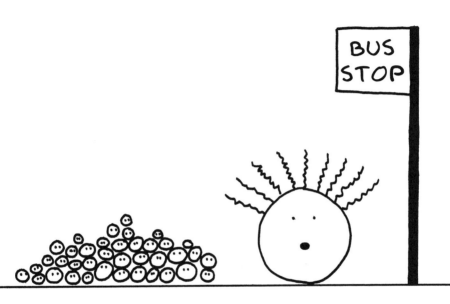

The shy man shook with fear, as a small
group of school children joined him at
the bus stop.

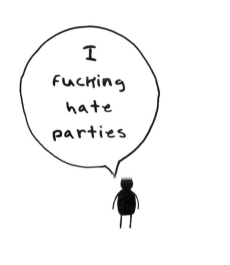

I feel so utterly trapped

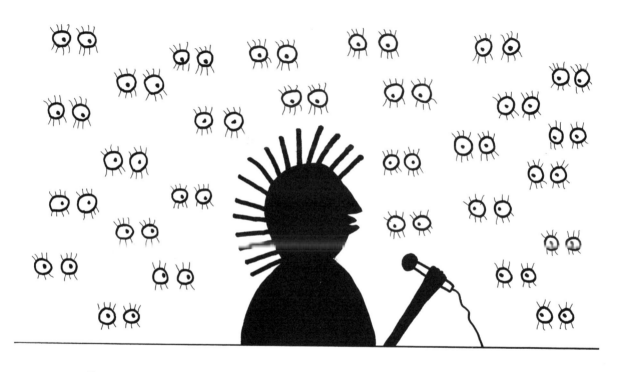

By day he is a factory worker
But by night he is a Rock n Roll star

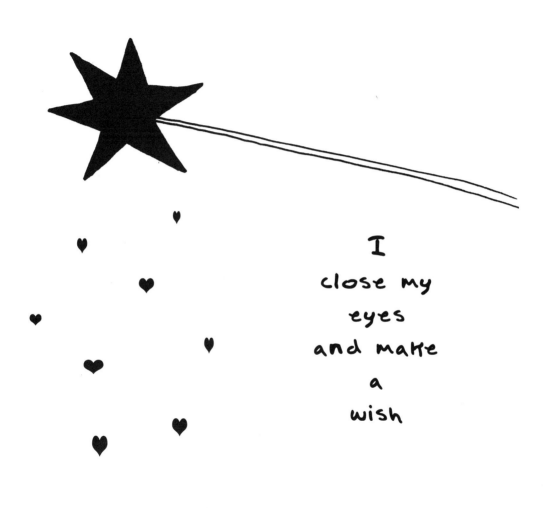

I
close my
eyes
and make
a
wish

Be still
my beating
heart

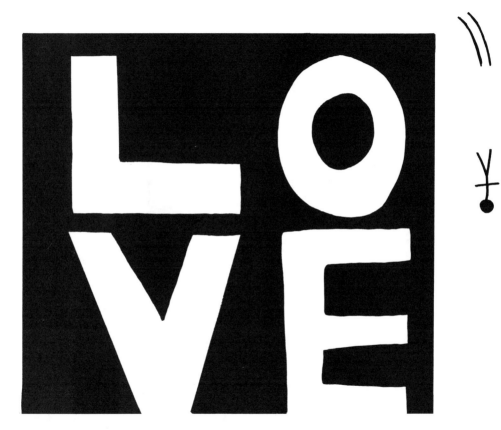

I wrote a thousand love songs
and sang them from my heart.
But when I said they're all for you
you laughed and laughed and laughed

When you are lonely
life goes on and on
and on and on and on

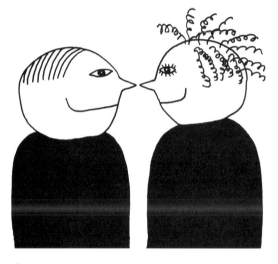

The Lovers just sit for hours
cooing at one another

It is disgusting!

Oh how you hate
Friday fucking nights

Gail 32. 5ft 6ins. small build
likes cinema and the arts
seeks male. 30-40 for fun
and possible LTR

What Gail likes cinema forgot to
mention were her scary psychopathic eyes
and her dominatrix desires

You have never eaten a pizza
so fast in your life.

"Are we going to
have sex now?"

"No we are not"

Goth girl — you make my heart twirl
You make everything — moody

It seems the whole world
is having sex apart from you

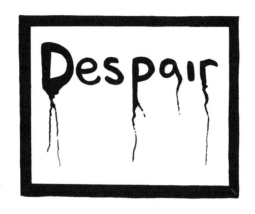

Your offer of love is declined.
She has chosen another.
You spend the rest of your days
painting pictures of despair.

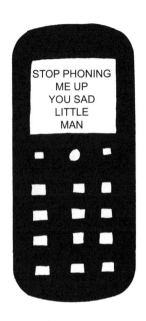

Oh how her heartless message
has scared your delicate heart

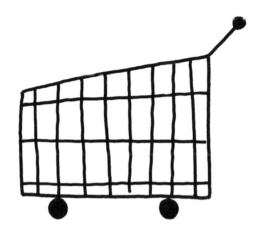

You go shopping for onions and love.
You have been told the best place to find
love is in the supermarket.
You wander the aisles for hours and hours
but to no avail.
You select two onions and go home and cry.

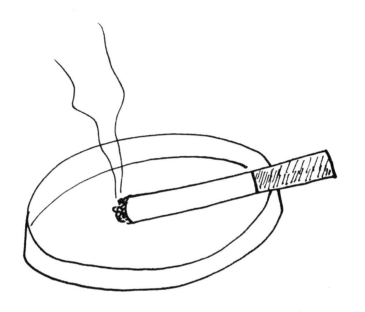

I miss you

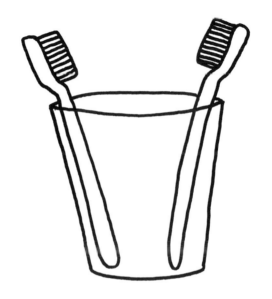

She has gone
All that remains is the faint
whiff of counterfeit perfume
and her beautiful toothbrush

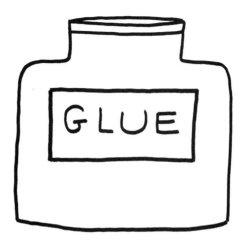

The love-struck unfortunate
spends his days sniffing glue.

For he cannot bear to think of
another boy holding hands with you

Stop knitting and listen to me

I have given you everything
but still you refuse to speak to me.

You are a rubbish girlfriend
and my mother was right about you

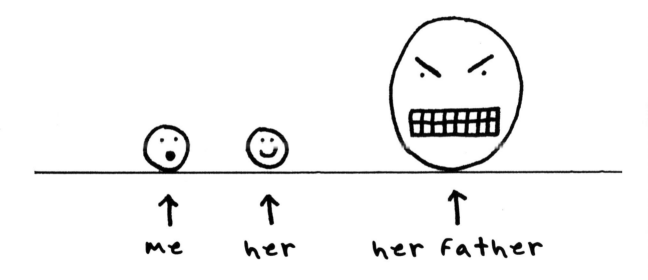

Stop being so dramatic
I only said 'I might'
be pregnant

My girlfriend

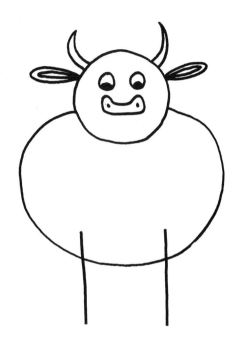

My ex-girlfriend
(cow face)

You sit in the darkness. A double whisky in one hand, a cigarette in the other, and vow never to go speed dating ever again

Girl with a
borderline
personality
disorder

Me
(I have run away)

Sometimes life
just brings you down

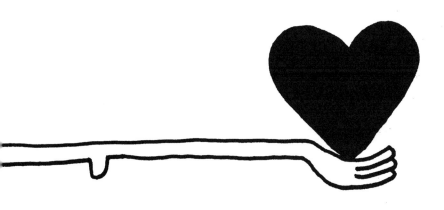

Take it, Dear Maker
for I don't want it
anymore

Sometimes I just like to withdraw from the world and think about stuff.

(I am doing it now)

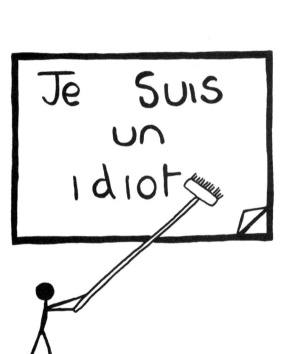

A BAD NIGHT

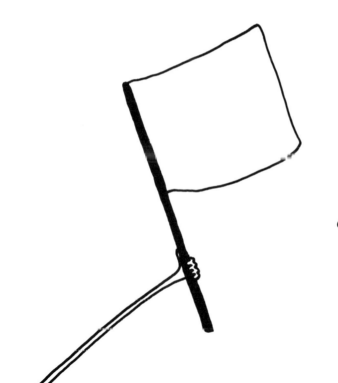

at 3.07am the white flag is finally waved

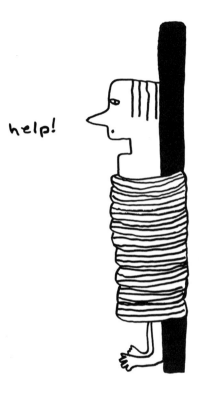

The hostage sees no way out

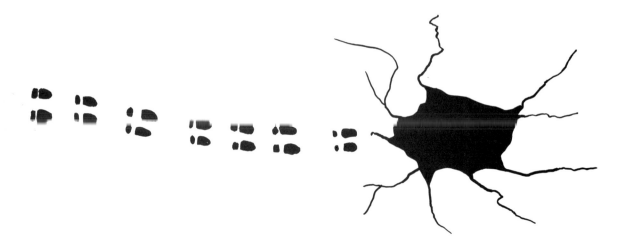

Beware
you are
walking
on thin ice

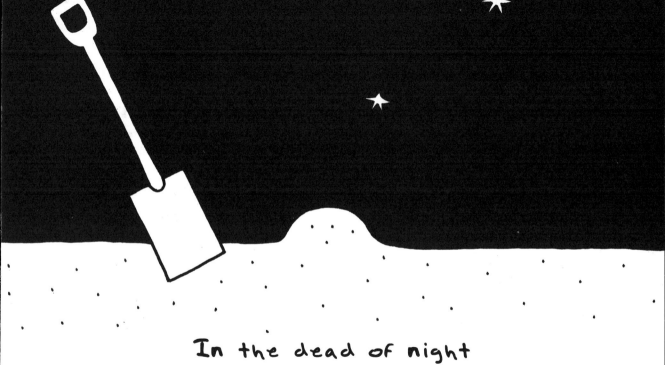

In the dead of night
you bury all of your hopes and dreams

The
Booker prize
←

To be
pulped
→

The little book's glittering career
suddenly came to a humiliating end

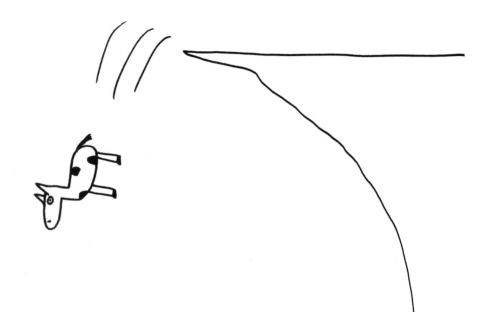

After yet another scathing review
the Pantomime Horse could take no more

HOPES AND
DREAMS
PROHIBITED

THE DOOMSDAY CODE

WE ARE FUCKED

Self harm (1)

Self harm (2)

Mirror mirror on the wall
how can you be so fucking cruel?

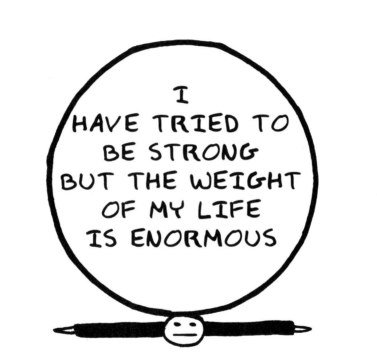

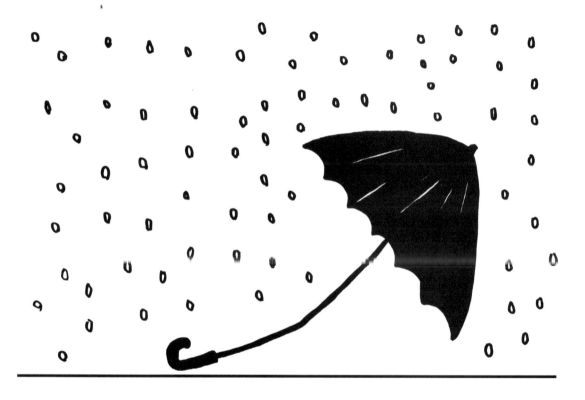

Oh how the battered umbrella
longed for the rain to stop

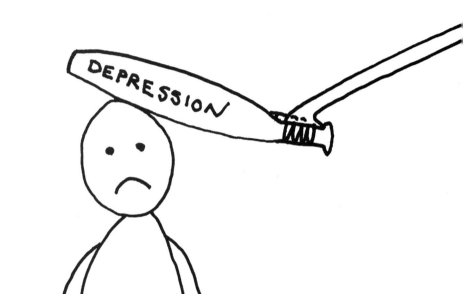

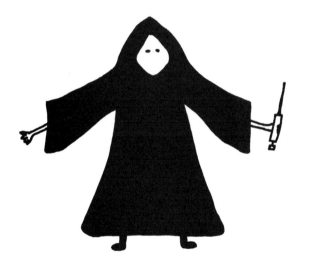

Trust me, I'm a
psychotherapist

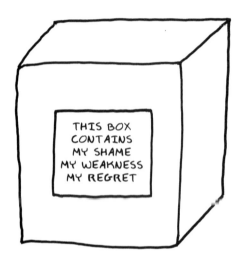

HANDLE WITH CARE

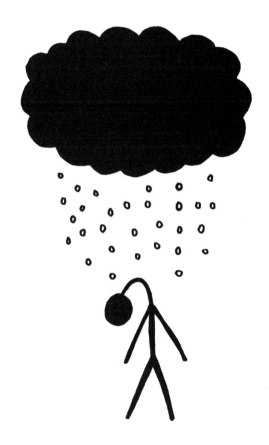

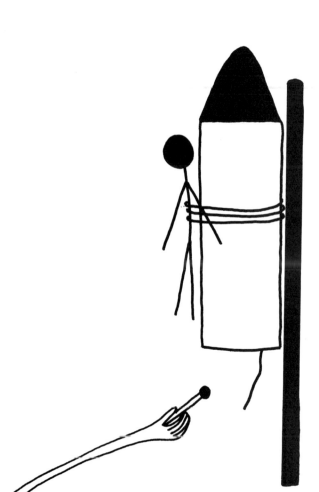

Escapism No1

Escapism No2

The neighbour's cat

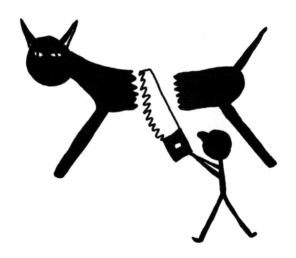

You only want to meet up
when you are feeling
depressed

You never phone me when
your life is good

Look — do you want to
go for a pizza or not?

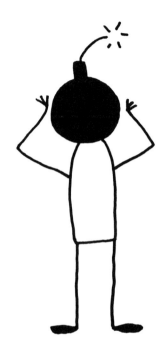

TICK TOCK TICK TOCK TICK
TOCK TICK TOCK TICK TOCK

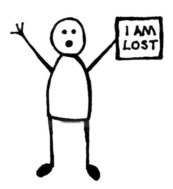

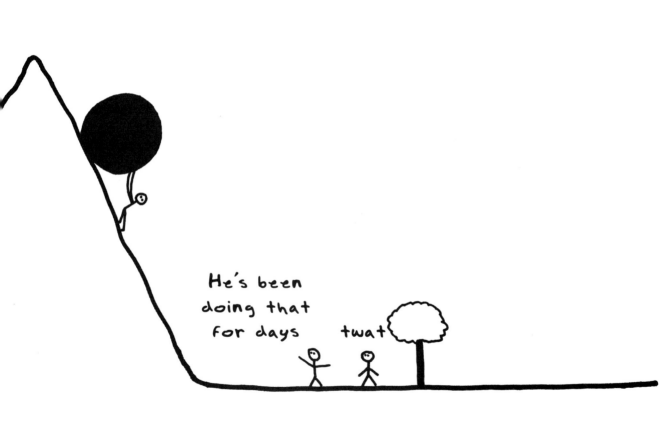

I live in a box. It is warm and safe and dull. I would like to leave my box and go disco dancing with you but I am too afraid. I would like to leave my box and spend the rest of my life with you in the real world. But I am too afraid to do anything. That is why I live in this box. I hate this box

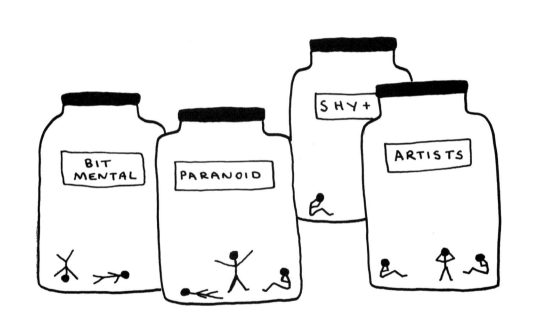

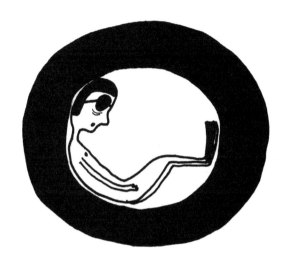

I decide to hide in my favourite hole
and wait for the drama to pass

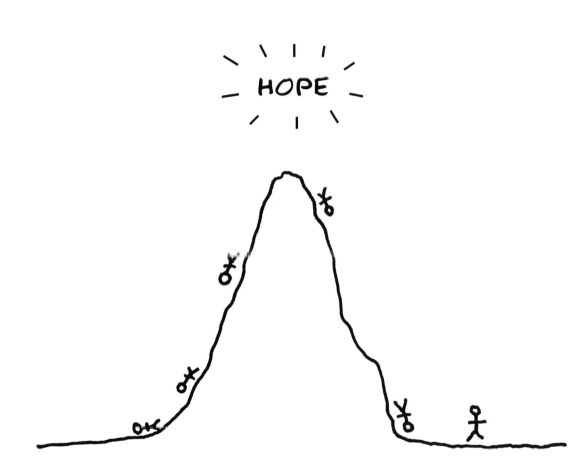

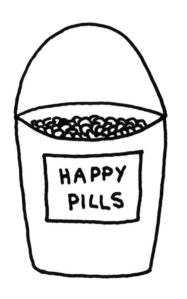

Hard
to
swallow

I am
the
Messiah

No, you
are
Bipolar

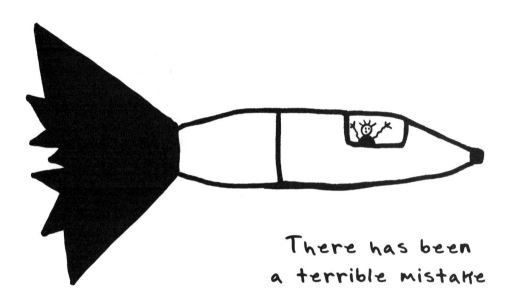

There has been
a terrible mistake

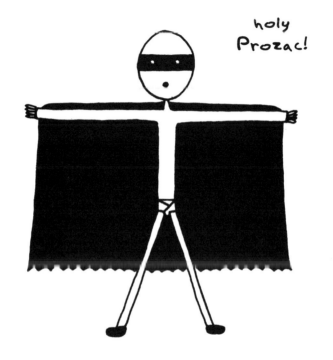

The Caped Crusader Of Gloom
has come to save us

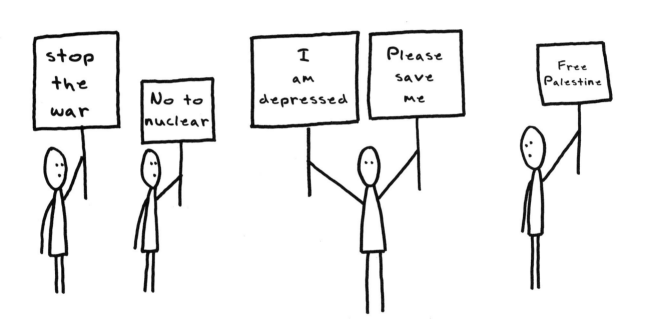

Poor social
skills
have left me
isolated and
slightly
melancholy

It is time to reflect upon your achievements thus far...

Oh how you cry and cry and cry

Trust me Father
my hell is far worse
than yours

I'd like
you to close
your eyes
and pretend
to be a baby

Oh for
God's sake!

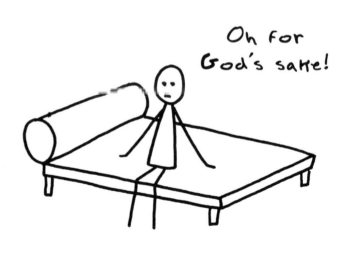

The ghastly knitted jumper your Bearded Granny made you every Christmas.

Oh how it made you itch but still you had to wear it.

Your parents call a family meeting.
They want to know what you are going
to do with the rest of your life?

Despite being 40 — you still have no clue

I once lived in a cul-de-sac
It was truly awful

The place where your parents kept
you captive for **18** years

Just thinking about it makes
you shudder

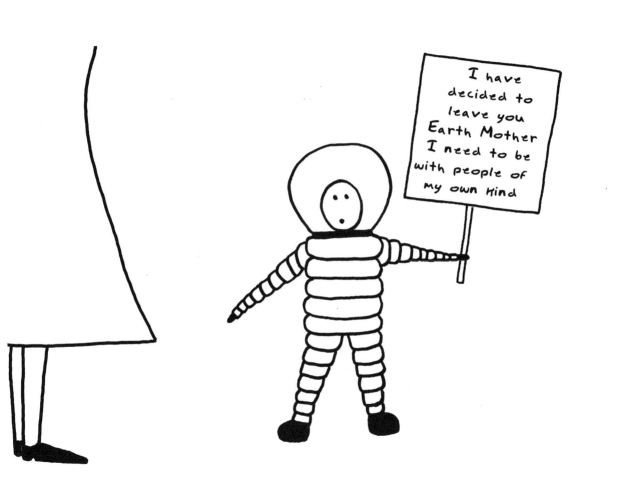

Those dreadful disco nights
Just thinking about the last
dance makes you want to cry.

Why did she reject you — why!

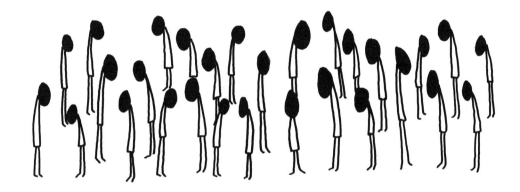

The School Reunion
(shudder)

They have died.
Every single one of them.
When Mother returns from
her holiday, she will kill you.

The shy sun never dared to shine

I am not waiting for
something bad to happen

I am waiting for something
good to happen

Be Brave

Leave your pride at the door
and just tell the truth

I am diagnosed as being
schizoid passive aggressive

I quite like it

We are all afraid of something

Only your soul goes to heaven.
The rest of your body gets eaten
by worms or becomes ash (depending
on your personal preference)

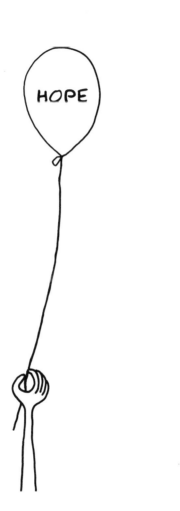

HOPE

Don't
Let
Go

SMILE

though your heart
is breaking and
you feel like a
misfit and no one
ever calls to ask
if you would like
to go to the
disco

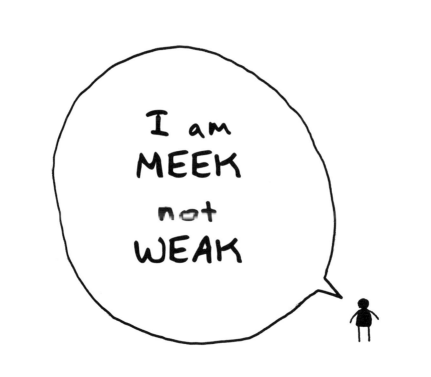

"I've changed my mind — I want to live"

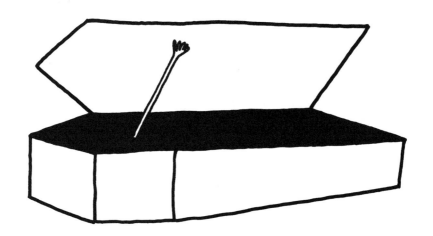

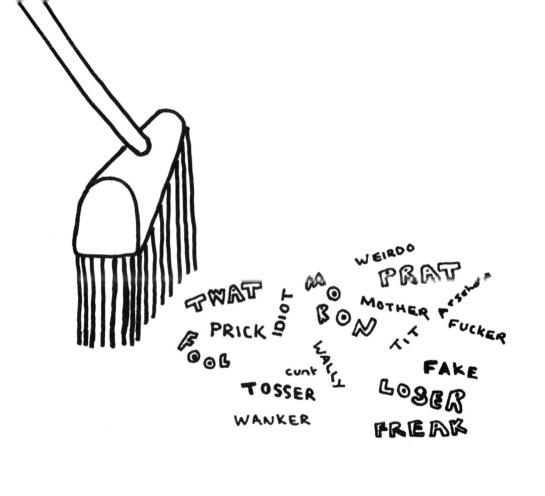

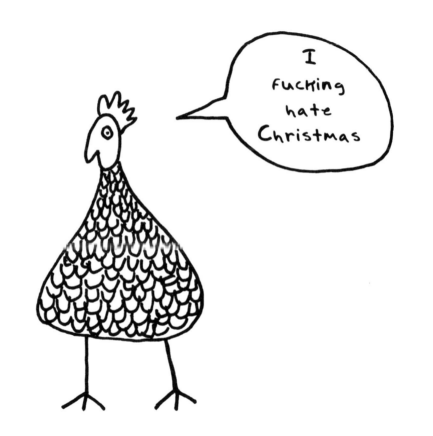

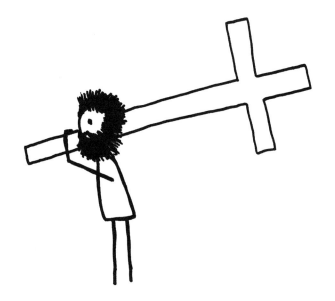

Christmas isn't about you
It's about JESUS !!!

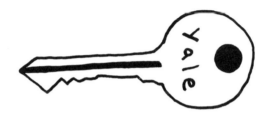

The key cost you £275,000
You wave it at everyone you meet
It is your greatest achievement in life
How proud you are of your £275,000 key

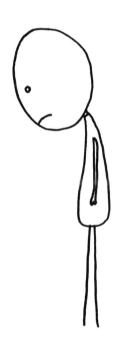

Don't let the
ordinary
change your
~~extraordinary~~
ways

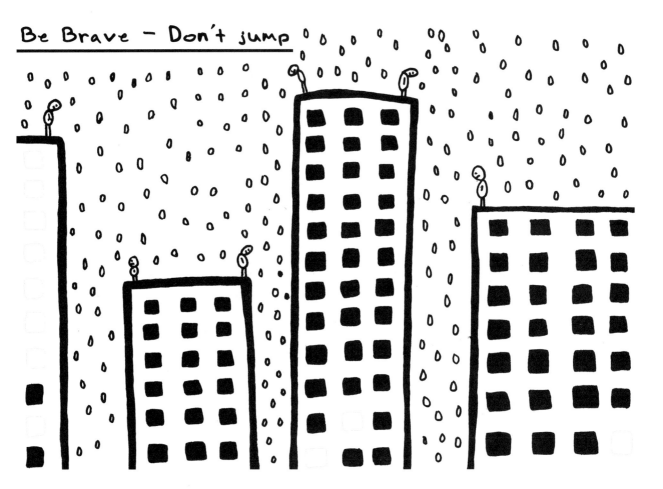

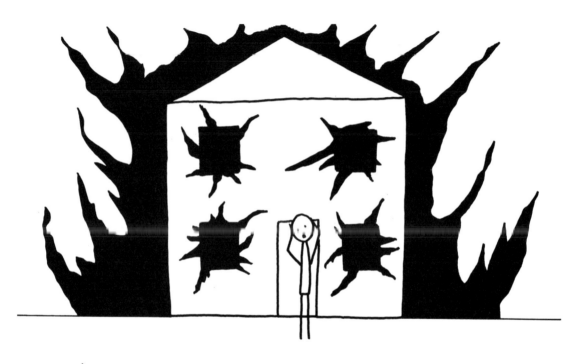

When all is burning down around you
the first thing you should save is yourself

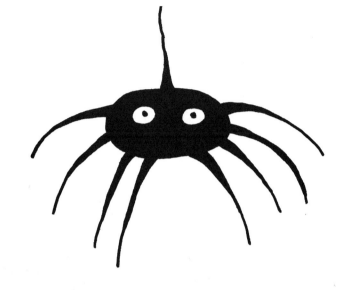

Don't be frightened of the spider
for he's just as scared as you

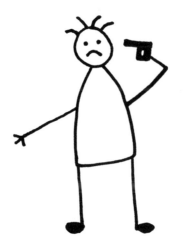

I'm too bloody happy

To achieve one's dreams
one must sing them — loud and clear
so that the Gods may hear

You travel this land
battered suitcase in hand
searching for someone
who will finally understand

After two years of solitude,
I emerge from the manhole
practically unscathed

There is a place that I once knew
Cold and frightening and bitterly blue
If you should find yourself there too
I'll hold your hand and walk with you

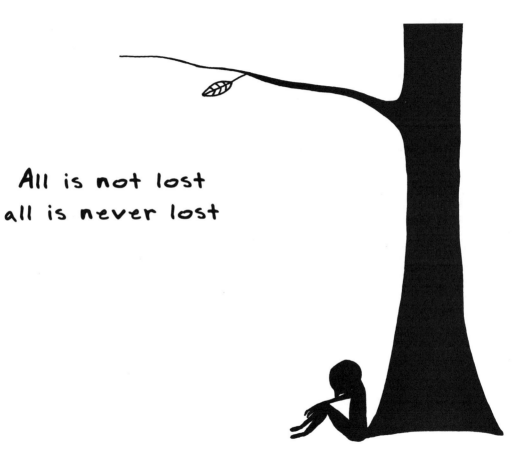

All is not lost
all is never lost

Everything is possible

I no longer
hear
the voices
in my
head

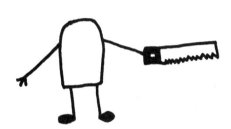

My About Me Page

···
···
···
···

.... to be continued and updated
as and when brilliant things occur

I suppose you think you could've done better, don't you?
Something I missed, wasn't there? Well put your money where
your mouth is and draw me a picture. I promise not to laugh.

Thanks to my agent Annabel Nash, Eleanor Birne, Helen Hawksfield and all at John Murray for their support and advice.